A HANDBOOK OF
CELTIC ORNAMENT

JOHN G. MERNE

A complete course in the construction and development of Celtic ornament for Art and Craft Students, with over 700 illustrations.

ⅭⅮERCIER PRESS

The Mercier Press Limited
P.O. Box 5
5 French Church St., Cork.

24 Lower Abbey Street, Dublin 1

A HANDBOOK OF CELTIC ORNAMENT

ISBN 0 85342 403 9

Twelfth Edition 1994

Printed in Ireland by Litho Press Co., Midleton, Co. Cork.

INTRODUCTION

IN THE course of his original introduction to this book author John G. Merne wrote:

"Man's earliest attempts at decoration were reserved for objects which were to him of more than ordinary interest or significance; for the tribal totem, the insignia and ceremonial apparel of the druid or the chief, and above all, for the memorials of the mighty dead. In the beginning these decorations were extremely simple in character; a few dots, a line, a spiral, or a series of them, arranged in a limited variety of patterns formed by repeating a selected unit.

The development of these simple motifs was influenced in a large measure by the effects of environment and climatic conditions on those who employed them, and reflects the gradual progress of the separate nation-groups along their own lines towards fuller knowledge and power.

National styles of ornamentation ultimately emerged, so full of distinctive detail and complexity that to the lay mind they have nothing in common. Yet, it will be found that from the same simple beginnings have sprung the most dissimilar forms of artistic symbolic expressions, be they Greek, Roman, Moorish, Egyptian or Celtic."

This book is concerned only with the last of these. It takes a few basic symbols or ideographs and develops them into a systemised method of construction for most forms of Celtic decoration. Having used this book in the artroom for many years I am glad to have an opportunity to introduce the Merne Method to a new generation.

The design that has been constructed for print rarely looks at ease on a piece of pottery. What looks fine on leather may look ridiculous when embroidered on linen. Realising this, Merne formulated a carefully graded scheme which enables the reader to adapt the principles learned here, to other media.

This book is a challenge both to the student and the professional artist to take a part of our tradition and make it their own, to use, to repeat, but most of all, to develop.

Caoimhín Ó Marcaigh

INDEX TO PLATES

4

1 SYMBOLS OR IDEOGRAPHS

HERE are a number of symbols found in primitive art which are derived from a common origin. They are simple Ideographs or signs, and denote what we might call Nature Symbols. It is the aim of this handbook to show, how from some of these simple symbols, the highly intricate ornament found in the copies of the Gospels, on Crosses, and other works of ancient Irish craftsmen and their pupils on the continent, has been developed. By a close study of these symbols, one can make endless patterns of decorative value which may be afterwards applied to all classes of craftsmanship.

1. Denotes the Four Seasons; the Four Winds; Four Cardinal Points; the Rays of the Sun.
2. Addition of horizontal to vertical gives movement.
3. Three rays with end lines give movement (Fylfot).
4. Swastika. Points of compass, with movement left to right. Sunsign.
5. Another form of Swastika, movement as in 4. Sunsign.
6. Four rays from a common centre surrounded by a ring or circle from which the rays project. Sun with rays. Compare with 18.
7. This is similar to 2, but line joining horizontals is oblique instead of being vertical.
8. Another form of Swastika got from 7, showing movement.
9. Double Axe of Crete, developed from 7, open ends joined.
10. Figure of eight, got from 9. Two circles used instead of two triangles, and from which the S curve sprang, or *vice-versa.*
11. Single S curve. *This curve is, in the Author's opinion, the important one used in the development of Celtic Knot-work.*
12. Chinese Yang-yin. This is the same motif as the Celtic Boss found upon the old stone crosses.
13. Circle with centre, shows movement.
14. Circle with centre from which springs a spiral, denotes a whirlpool or whirlwind.
15. Double spiral deduced from 14. Whirlpool and whirlwind.
16. Circle with tangential rays, showing movement from left to right. Sun moving through the heavens. (4 combined with 13.)
17. Developed from 12, with tangential rays to produce effect of movement. Celtic Boss.
18. Egyptian sunsign or wheel symbol. This is 1 with 13.
19. Double S curve within a circle. Sunsign. Movement shown.
20. Curved form of Swastika. Compare with 4.
21 and 22. Two symbols found in Celtic ornament.
23. Shield of David. Derived from 9.
24. Triangle with vertical line. Egyptian.
25. Two Sacred Triangles. Compare with 9.
26. Tau Cross, found in Celtic ornament, signifying Wisdom.
27. Circle with tangential rays, derived from 4 and 13, or from 16 and 18.

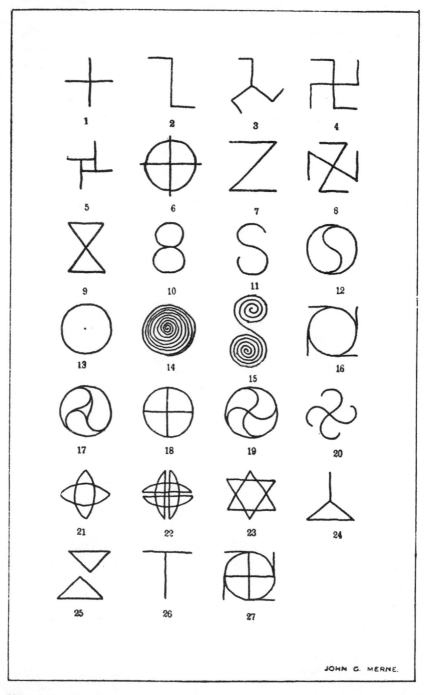

Plate 1

7

2 SYMBOLS OR IDEOGRAPHS

THIS chart shows the relationship between the various symbols found in primitive art throughout the world. By carefully following along the directional lines drawn between the symbols, one can easily trace the gradual growth of each from the one preceding it, and at the same time determine the common origin from a vertical and horizontal line, which are shown in heavy black in the centre of the chart.

JOHN G. MERNE.

Plate 2

9

3 CURVED SWASTIKA (Ideograph No. 20)

THIS plate shows the curved Swastika 20, presenting horizontal and vertical S curves in a combination from which a large number of all-over patterns are evolved, and to which all Celtic Knotwork owes its origin.

The arrangement of the Swastika in the various diapers is designated as clockwise or anti-clockwise, that is, the appearance of movement of the unit seems to be in a right-hand or left-hand direction. C means clockwise; AC anti-clockwise.

Four examples are given of diaper or all-over patterns, in which the curved Swastika is the unit of repeat.

1. Diaper pattern based upon vertical lines of AC curves alternating with vertical lines of C curves.

2. Diaper pattern based upon vertical lines of AC curves.

3. Diaper pattern based upon alternate C and AC curves both vertically and horizontally.

4, 5, 7 and 8. These show various arrangements of the Greek Cross as the basis of other patterns, in which the curved Swastika appears.

4. Pattern got by using a series of Swastika Symbols 8, to produce a diaper of Greek crosses.

5. Arrangement of Greek crosses as basis of pattern 6.

7. Basis of design on which diapers 1, 2 and 3 were arranged.

8. Arrangement as 4 to produce pattern 1 on Plate 4.

NOTE

One would be well advised to draw these patterns several times (*not trace*) to become familiar with the unit and its various arrangements. The unit will fit within an even-armed cross, containing three squares in its upright arm and three squares in its horizontal arm and known as a Greek Cross.

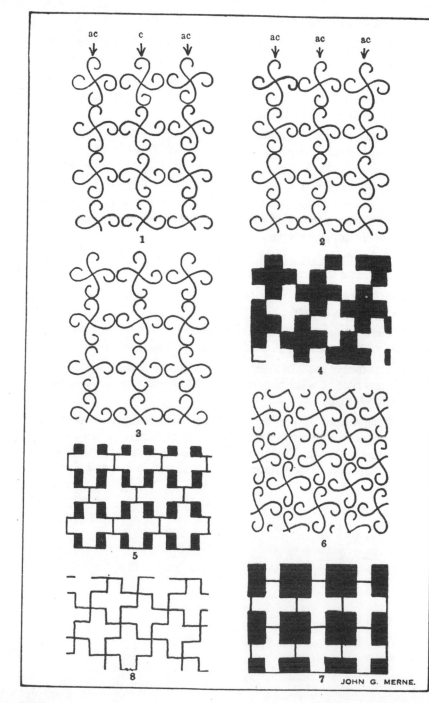

JOHN G. MERNE.

Plate 3

11

4 CURVED SWASTIKA (Ideograph No. 20)

THE next step from the patterns shown on Plate 3, is to the beginning of the Trumpet Pattern. This is clearly shown in the examples 3, 4 and 5.

In example 3 the S curve is used, and the circles are arranged in horizontal and vertical lines.

In example 4 the arrangement of the circles is similar to the last example, but the C curve is here introduced. This C curve is really the product of two S curves, one right-handed, and one left-handed, the two crossing over to produce an X or double C curve.

This result of the crossing over is shown clearly in 2. The tangential lines appearing on Symbol 27 are very clearly discernible on these Trumpet Patterns.

In 5 the circles are arranged in horizontal rows, but are stepped vertically, and the S curve is used here as in 3.

6 shows a series of horizontal S curves linked together and forming a wave-like border.

7. Here we have the wave-like border turned over on itself horizontally. This pattern will be found in Grecian and other art.

8. By joining the loose ends of the S curves where they link, we get a new type of wave pattern. Note the likeness of this pattern to Symbol 12, Plate 1.

9. This diaper is got by combining the horizontal wave-like pattern 8 with a similar vertical wave-like pattern, and can be used as a counter-change. The basis of this is the same as that used in the construction of the Trumpet Pattern shown in 3, 4 and 5 above.

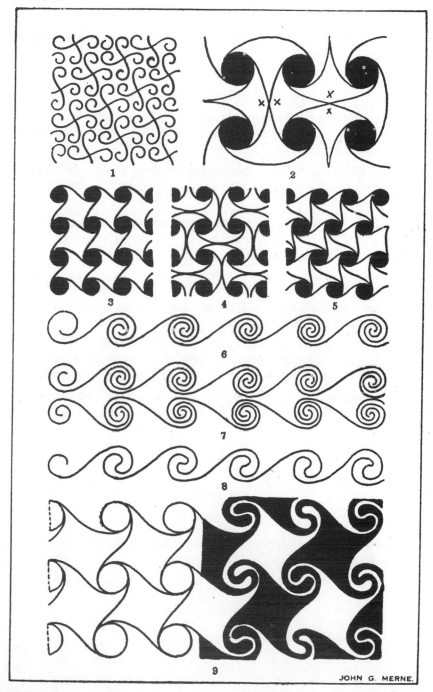

1

2

3

4

5

6

7

8

9

JOHN G. MERNE.

Plate 4

13

5 CURVED SWASTIKA (Ideograph No. 20)

VARIOUS forms of counter-change as well as boss-like diapers are dealt with on this plate.

1 This shows a form of counter-change which uses the same foundation as the Trumpet Pattern, Plate 4.

2. This is a further development of 1 as a diaper, and into which is introduced the Celtic Boss or Chinese Yang-yin Symbol. See Plate 1, Symbol 12.

3. A form of horizontal counter-change is given which is based on the wave-pattern, the S curves being in a vertical line one above the other.

4. In this counter-change the S curves are stepped. Both these patterns are worked out on the same foundation as the diapers shown at the right-hand side of each.

5 and 6 give two other forms of boss diapers. If these diapers and counter-changes are set out as a number of circles first, and then joined up with the S curves, there will be no difficulty in drawing and completing them.

7 and 8 show vertical counter-changes, the basis of these being given in 9. The curved vertical arm of the Swastika is used in this case, the horizontal arm of the Swastika being omitted.

9. This shows clearly the foundation on which the two counter-changes 7 and 8 are built.

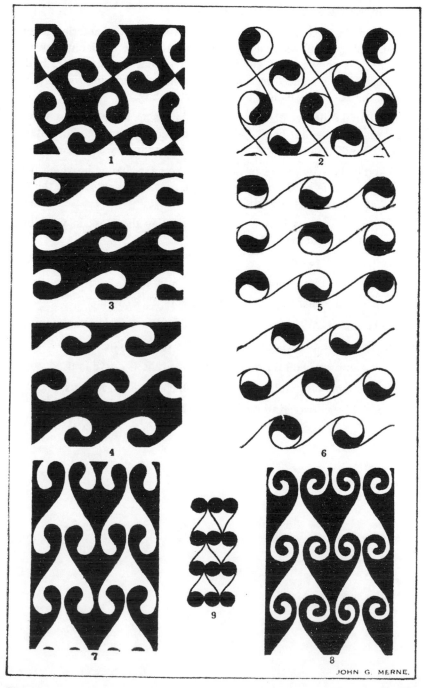

JOHN G. MERNE.

Plate 5

15

6 BORDERS AND PATTERNS

IN example 1 on this plate we have the first sign of interlacement which clearly shows that by superimposing the horizontal wave border (as shown on Plate 8) upon a similar wave border, both running in the same direction, we produce the first interlaced pattern, the basis of which is shown directly above it.

2. This border is derived by superimposing a right-hand wave pattern upon a left-hand pattern, producing again another interlaced band or border, whose basis is shown directly above it.

3 and 4 show two types of horizontal counter-change in which the C curve is used, the basis in each case is the same, but the C curves are arranged differently.

5. This shows various methods of treating the Boss in working out the Trumpet Pattern.

6. Curved Swastika.

7. Chinese Yang-yin or Celtic Boss Pattern.

8. Curved Swastika in circle, Symbol 19.

9, 10 and 11. Three other forms of Celtic Boss Patterns.

12. Four spirals springing from a cross or Swastika.

13. Example of spiral ornament in which the C curve is used.

14. Example of spiral ornament in which the S curve is used.

15 and 16 are two examples of curved Swastikas.

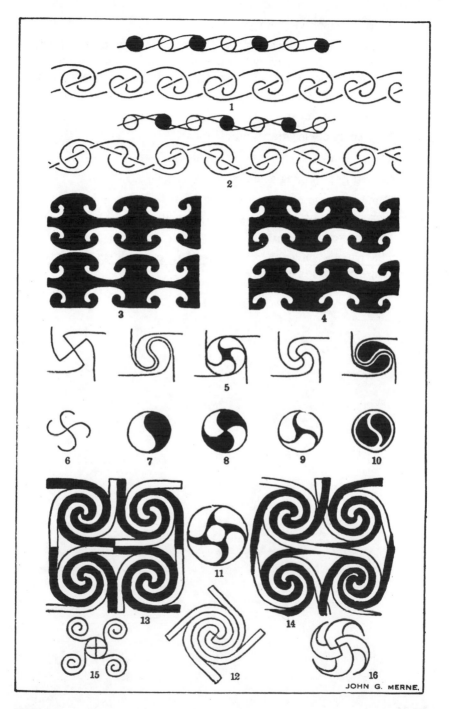

JOHN G. MERNE.

Plate 6

17

7 THE TRUMPET PATTERN

1. This very fine example of the Trumpet Pattern shows clearly the peculiar characteristics of that beautiful form of decoration. Its construction is shown by analysis, and one can easily follow it out by a study of the small squares.

2. Centre circle drawn.

3. Four small circles drawn on diagonals.

4. S curve drawn in centre circle. (Chinese Yang-yin.)

5. Curved lines joining small circles to large.

6. Centre of large circle constructed from 4.

7. Spirals introduced into small circles and trumpets completed; drawing ready to finish as 1.

8. The pattern shown here is a modern example in which the centre consists of interlacement.

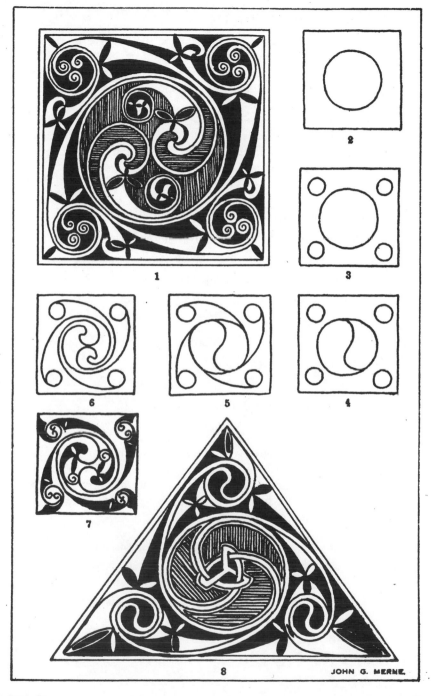

1

2

3

6

5

4

7

8

JOHN G. MERNE.

Plate 7

19

8 S-CURVE (Ideograph No. 11)

THIS plate shows clearly step by step how the S curve in various arrangements produces the different knot-borders.

The construction of the S curves and the borders developed therefrom will be easily understood by a close study of the sketches in conjunction with the letterpress.

By drawing each arrangement several times (*not tracing*) one will become familiar with the method, and develop other types of Knotwork, bearing in mind the use and application of the S curve, which is the key to the construction.

1. Simple S curves.

2. S curves joined, wave pattern produced.

3. Right and left wave patterns superimposed.

4. Another wave pattern from joined S curves.

5. Two wave patterns 4, superimposed.

6. Right and left wave pattern 4, superimposed.

7. S curves linked together.

8. Ends of S curves 7, joined up producing Figure 8 Knot.

9. Right and left S curves linked.

10. Right and left S curves 9, joined, Simple Knot.

11. Right and left S curves linked and open.

12. Knots produced by joining the ends of 11.

This method emphasises the simplicity which underlies the construction of all the examples of borders which follow in the book. By familiarising himself with the Knots, and by drawing these patterns frequently, the beginner will attain a skill in Celtic design in a very short space of time.

NOTE

1, 2 and 3 are based on the same motif.

4, 5 and 6 are based on the same motif.

7 produces 8.

9 produces 10.

11 produces 12.

1

2

3

4

5

6

7

8

9

10

11

12

JOHN G. MERNE.

9 S-CURVE (Ideograph No. 11)

1. Right and left S curves linked.
2. Knots developed by joining ends of S curves 1.
3. Right and left S curves linked. Long S curves used.
4. Knots developed by joining ends of 3.
5. Right and left S curves linked.
6. Pattern developed from 5.
7. Right and left S curves linked and open.
8. Pattern developed from 7.
9. Right and left Z or angular S linked.
10. Pattern developed from 9.
11. Pattern developed from 9.
12. Pattern developed from 9.

NOTE

1 produces 2.

3 produces 4.

5 produces 6.

7 produces 8.

9 shows the S curve taking a straight form of ideograph, Symbol 7, which gives a rigid appearance to the Knotwork. Movement is absent and a restful impression is given. This Z form is introduced later on in the construction of Fret Patterns and other types of similar ornament.

10 is got by joining the ends of the Z, and if examined closely will be found similar to Symbol 23, whilst Symbol 9 is clearly defined.

11. This is a further development of 10.

12. This is a curved form of 10.

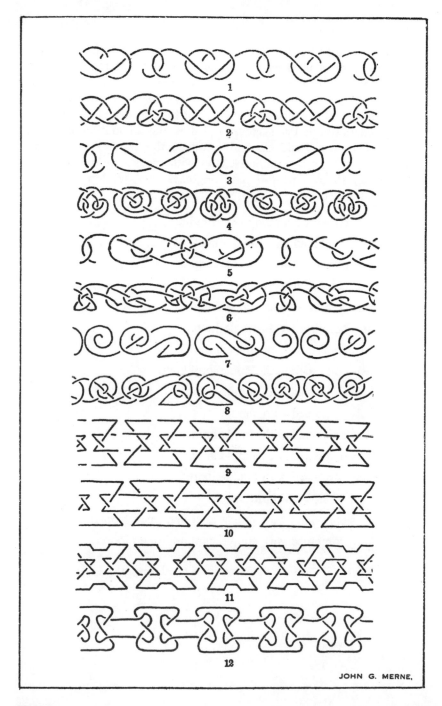

1

2

3

4

5

6

7

8

9

10

11

12

JOHN G. MERNE,

Plate 9

23

10 BORDERS

THIS plate shows a number of simple borders, in which a simple Z or S form is used as a basis or foundation of the design, in combination with the various knots, to produce artistic and useful decorative motifs. In each case the knot used to produce each particular border is given at the side of that border. The drawings are given as simple line sketches and show the foundation on which the student can build up and complete the borders as ribbon-work, as well as to familiarise him with the author's method of designing, so that he too may originate and develop the work along lines of his own.

1. Basis on which each border is built.
2. Basis combined with simple knot.
3. Basis combined with double loop.
4. Basis combined with single loop.
5. Basis combined with simple knot.
6. Basis combined with single loop.
7. Basis combined with single loop.
8. Basis combined with double loop knot.
9. Basis combined with Figure 8 knot.
10. Basis combined with simple knot.
11. Basis combined with simple knot.
12. Basis combined with simple knot.
13. Basis combined with double loop.
14. Basis of next two borders.
15. Basis combined with simple knot and open loops.
16. Basis combined with simple knot and open loops.

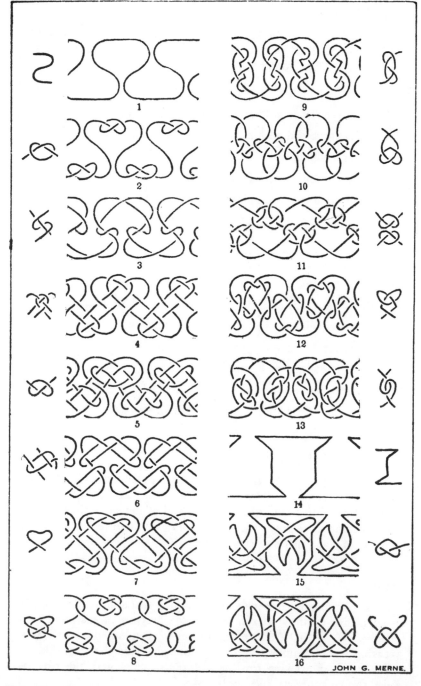

JOHN G. MERNE.

Plate 10

25

11 BORDERS

On this plate are given a number of other simple borders, and as in Plate 10 the knot used to produce each particular border is given at the side of that border.

1. Basis on which each border is built.
2. Basis combined with simple knot.
3. Basis combined with simple knot.
4. Basis combined with Figure 8 knot.
5. Basis combined with Figure 8 knot.
6. Basis combined with simple knot with loop.
7. Basis combined with double loop knot.
8. Basis on which each border is built.
9. Basis combined with simple knot and loop.
10. Basis combined with simple knot and link.
11. Basis on which each border is built. Celtic Step Pattern.
12. Basis combined with simple knot with loop.
13. Basis combined with open loops, right and left.
14. Basis combined with simple closed loops.
15. Basis combined with simple open loops.
16. Basis combined with simple knot with loops.
17. Basis combined with wave pattern.
18. Basis combined with double knot.

The example of space filling shown at 19 gives a method whereby the squaring of the corners or outline produces a sense of rest and stability in the ribbon-work, and at the same time gives a real decorative feature without in any way interfering with the original characteristics of the design.

NOTE

The use of squared paper in the designing of patterns of all kinds is advocated by the writer as well as the drawing of each unit to a small scale, so that freedom of line may be attained as well as a pleasing form of filling, properly balanced. From the small sketch made a larger drawing can then be constructed with the ribbon-work shown complete and interlaced.

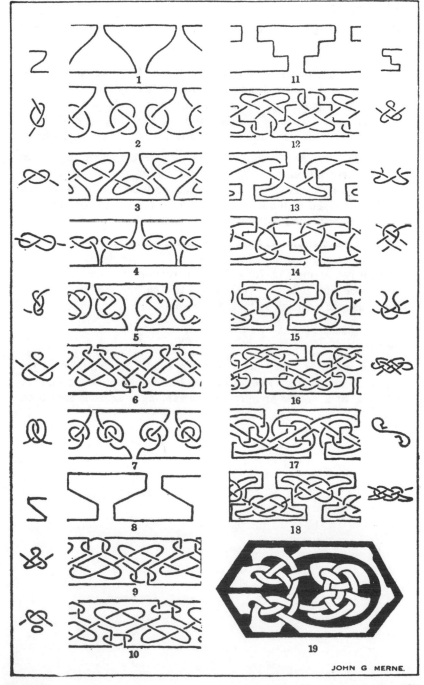

Plate 11

JOHN G MERNE.

12 KNOTS

THIS plate shows how a number of different knots can be developed from a single one.

1 C. This is known as the Simple Knot. Its development into more complex knots can be easily traced. It may only repeat over itself to fill a panel, but it can continue indefinitely in a horizontal direction either by repeating itself thus V, V, V, V, or as V, Λ, V, Λ, or as up, -up, -up, -up, or up, -down, -up, -down, -up, -down.

13 D. This is the Figure-of-8 knot. Its development into other knots is shown from 13 to 24. This knot having two loose ends, one at the top and one at the bottom, can be used for borders, or if locked or linked with another knot, can be used in the construction of diapers or allover patterns.

25 E. This is known as the Granny knot. From 25 to 36 are shown different arrangements, using this knot 25 as the basis. This form of knot is extremely useful in the construction of diapers as having four loose ends it can be worked into this particular class of decoration, as well as being suitable for borders.

NOTE

By the use of a thin mirror one can easily determine what the repeat of any of these knots will look like as borders or as diapers. The use of a mirror or mirrors in arranging designs is shown on Plate 22.

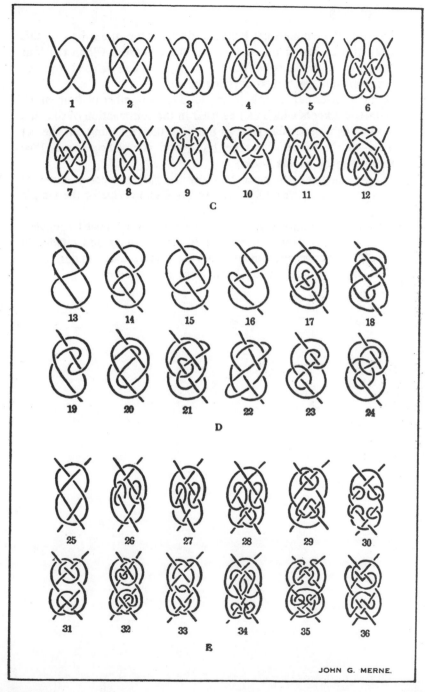

JOHN G. MERNE.

Plate 12

29

13 KNOTS

A SERIES of asymmetrical knots is given on the upper half of this plate. In each case 1 on each row is the unit from which the four succeeding knots are constructed. These knots can be used for ends of ribbon-work, or turned over for panels.

On the lower half of this plate are given a number of four ended symmetrical knots which can be used in the construction of diapers, by selecting a particular knot as the unit, then planning out the net on which the diaper is to be built, and completing same. (See examples given in this book.)

These examples are given to show the vast number of types of knots that can be created when one has a knowledge of the simple knots.

In all cases of knot-work, the "under and over" must be regular. No knot-work or ribbon-work should cross over or under twice in immediate succession, but it must go under, over, under, over, under, over, and so on until the work is complete.

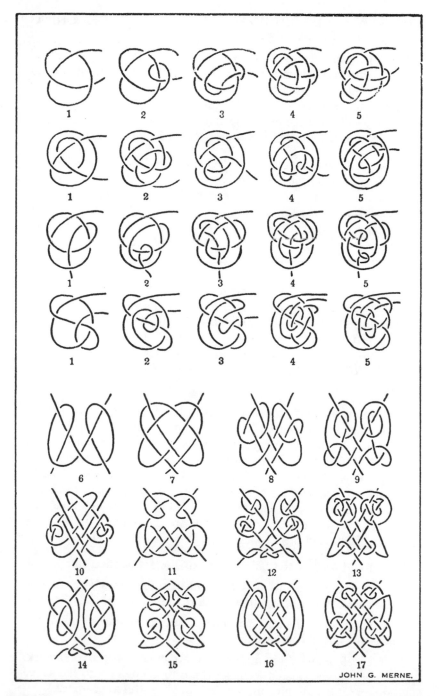

JOHN G. MERNE.

Plate 13

31

WHEN patterns of any kind are symmetrical they have a central axis, either vertical or horizontal, and whatever ornament lies at the left-hand side must be repeated on the right-hand side. Herein lies the simple solution to the difficulties of panel interlacement. By carefully following the instructions given below, one will have little trouble in producing very good designs after a little practice.

First draw the panel to the shape required, and with a central axis. Next draw a line from left to right, cutting across the central axis and continue until the line reaches nearly to the right edge of panel. Now draw a similar line from right to left, cutting through point of intersection of first line with the central axis, continue this line to left edge of panel. From one end of first line continue to draw a short distance in any direction. Repeat this on second line, starting from same corresponding point but working in opposite direction. Continue another portion of first line, and repeat same on second line, doing short steps at a time, eventually finishing up by joining the two loose ends of the original first lines.

Proceed next to draw a line at each side of the foundation line so that the space enclosed between these lines is equal in width to the Ribbon required. Continue until all the Ribbon is completed in this manner.

It is now an easy matter to thicken the necessary lines, so that the ribbon interlaces, that is, passes under, then over, then under, then over, and so on throughout the design. The writer can offer no rule as to the width of the ribbon in relation to the background, except, that the areas of ribbon should balance the area of background exposed. If the ribbon is narrow, the bareness of the background can in a great measure be relieved by the use of simple line ornament. (See Plate 34.) Defects that are liable to crop up, in the course of filling in the ribbon-work are dealt with on Plate 18.

1, 2, 3 and 4 show the building up of the foundation line.

5. The foundation line is shown dotted. The lines at each side of the foundation line give the width of ribbon-work.

6. Lines cleaned up, and the under and over arrangements of the interlacing put in correctly.

7, 8 and 9 shows three different treatments of the ribbon-work. The corners are squared to make the ribbon conform to the shape of the panel, and to give the whole a more restful appearance.

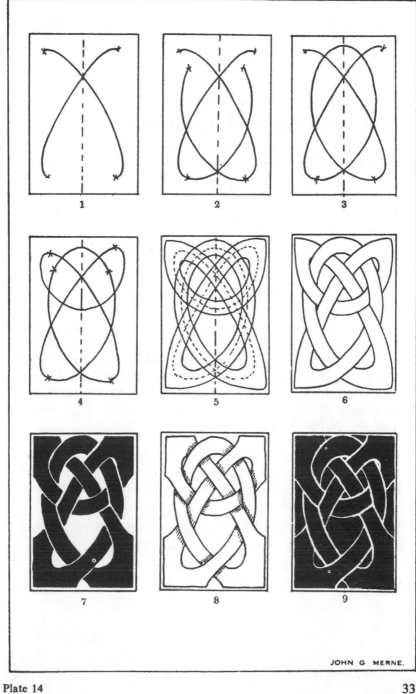

JOHN G MERNE.

Plate 14

C

33

15 PANEL DESIGNING

On this plate are given further examples of the method used in designing interlaced ribbon-work of all kinds.

1. This gives the panel with central axis shown dotted, and with the first part of foundation lines drawn.

2. Foundation lines continued further.

3. A further continuation of the foundation lines.

4. Foundation lines completed, and the lines at each side of the foundation lines drawn. These are shown dotted, and are ready for the arrangement of the under, over, under, over, and the final completion of the ribbon-work.

5. This shows the finished panel design, with ribbon-work light on a dark background.

6, 7, 8 and 9 show four different designs worked out on this principle.

Note

Mark out a number of similar panels on a scale not bigger than the ones given. This can be done by cutting an opening in a piece of card, to the shape required, and by using this to act as a guide or template. Place the card down on the paper and run a pencil round the opening. Draw the axis and then experiment in producing designs of different kinds to fill the particular panel drawn, using the method shown on Plates 14, 15 and 16.

The writer recommends drawing to a small scale, as by this procedure the designing becomes much easier, less stringy, better balanced, and more satisfying. When complete, it is easy enough to draw to the size required, from the small sketch already made.

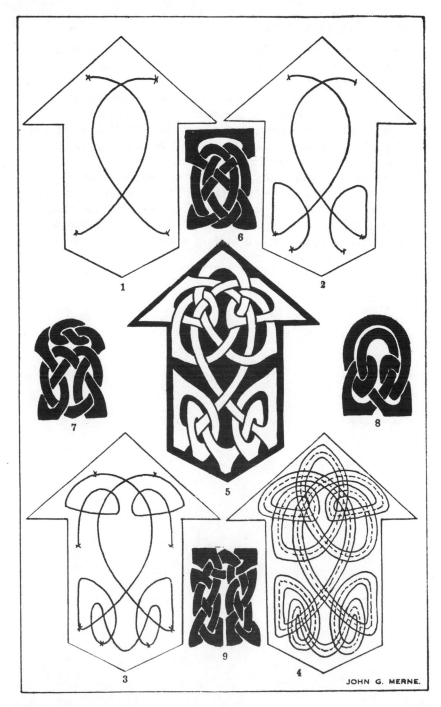

JOHN G. MERNE.

Plate 15

35

16 PANEL DESIGNING

THE examples of space filling shown on this plate are worked out on the system explained on Plates 14 and 15, the basis of all the designs being given in 1.

Attention is drawn to the rectangular panel at the bottom of the sheet. This shows how by squaring out the ribbon to fill the space, a better and more restful design may be got. This method is adopted also in the circular panels, the arrangement of the under and over, in all cases can be plainly seen.

The writer reiterates the advantages of constantly sketching, to a small scale, the numerous examples to be found on crosses, metalwork, and other objects bearing Celtic Ornament, so that the student will be enabled to learn the various phases of that work, and thereby produce original work of a high standard, and full of the spirit of the old craftsmen.

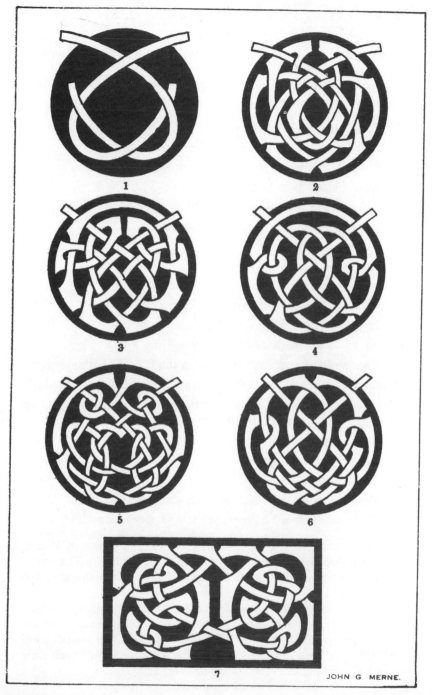

JOHN G MERNE.

Plate 16

37

17 FAULTS IN RIBBON-WORK AND CORRECT METHODS

ON the upper portion of this plate are shown a number of defects which are liable to occur with a beginner. Should they unavoidably occur, methods are shown of correcting them, and at the same time retaining the original character of the ribbon-work.

1. Weak right-angle bend.
2. Same strengthened by inner curve or fillet.
3. Loose loop which seems liable to untwist.
4. Ring added which locks loop.
5. Double loop which looks liable to straighten out.
6. Ring or link added which locks loops.
7. Loose twist with loop.
8. Same converted into knot.
9. No interlacement. Weak and loose looking.
10. Crossing over correct, but with loose loop.
11. Improved, but still weak at bottom.
12 and 13. Two methods of completing the knot.
14. This panel is given as a typical example of bad ribbon-work.
15 and 19. An example of space filling using the writer's method.
16, 17 and 18 give the correct methods for arranging angles or bends in ribbon-work, by the use of a fillet.
20. Two ribbons crossing over.
21. Four ribbons crossing over.
22. Three ribbons crossing over.
23. Example of weak interlacing with sharp inner corners.
24. Same strengthened by inner fillets and squaring outline.

The method of filling that the writer uses, and shown in 19 and 24, produces a very restful and satisfactory result, for whilst maintaining the original feeling, it conforms better to the shape of the panel itself.

In all cases the ribbon-work should continue properly behind these forms when adopted, so that though parts be hidden, the eye will naturally follow the flow of the ribbon line. The introduction of Animal or Bird forms should not be attempted until such time as one is a master of ribbon-work or interlacing.

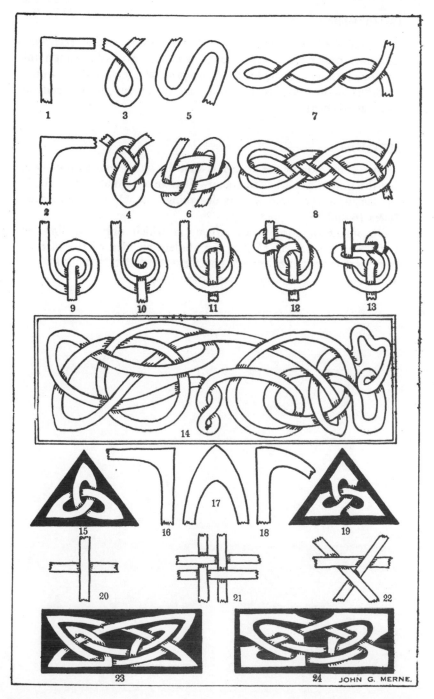

JOHN G. MERNE.

Plate 17

39

18 CORNERS

THE method of constructing corners is the same as that employed for panel design, and the student who has worked through the previous lessons, and understood the principles involved, will have no difficulty in grasping the idea underlying the development of all types of corners.

METHOD

The centre axis of the corner is first drawn as well as the space that the ribbon-work has to occupy. It is an easy matter to work in the design, in the same way as designing a panel, as described on Plates 14 and 15.

A number of corners are given, in which only the lines of foundation are drawn, to give the student an idea of the method used, so that he will be able to complete the design by building out the ribbon-work from these foundation lines.

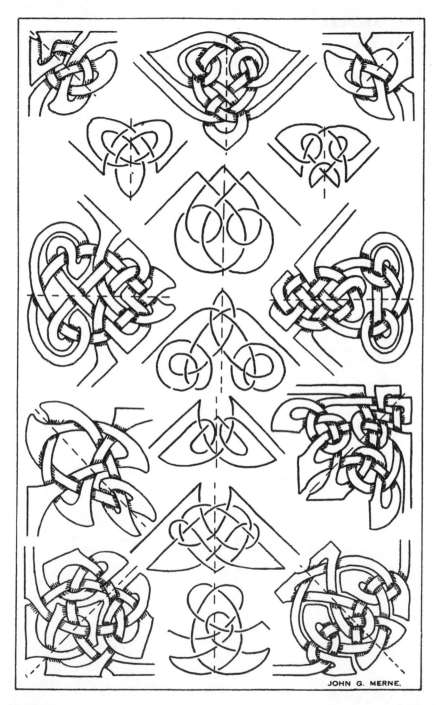

JOHN G. MERNE.

Plate 18

41

19 CORNERS

SOME further examples of corners are given on this plate which will be found of great value in the construction of Panels, Tiles, etc., and to give the student some other types to work from and to develop along lines of his own.

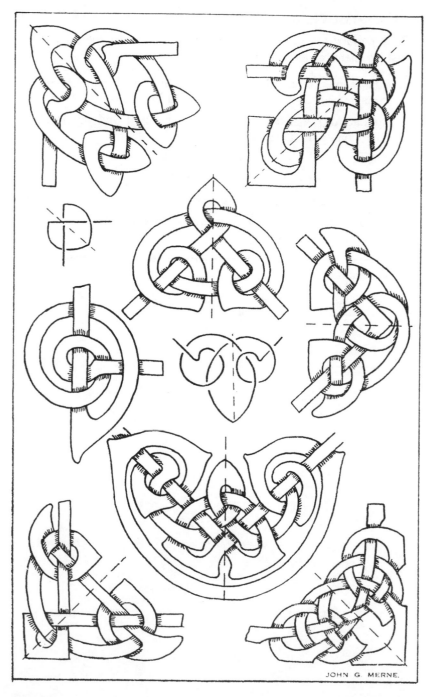

JOHN G. MERNE.

Plate 19

43

20 CROSSOVERS

THIS plate deals with triple-ribbon crossovers and the means of making them highly decorative.

1. This shows three ribbons crossing, and held together by a circular ring. Symbols 13 and 25 used here.

2. Similar to 1, but with ribbon and ring split and interlocked. The Symbol used is shown beside it.

3. Further splitting and interlocking. Basis as 1.

4. Another mode of treatment. Basis as 2.

5. Ribbons interlaced with three loops. Basis shown at side.

6. Ribbons interlaced with separate interlacing ribbon of three closed loops. Symbol as 5.

7. Ribbons curved and interlaced with circular ring. Basis of this is same as 1.

8. Ribbons looped and interlaced with ring. Three Sacred Circles within a circle form the basis of this crossover.

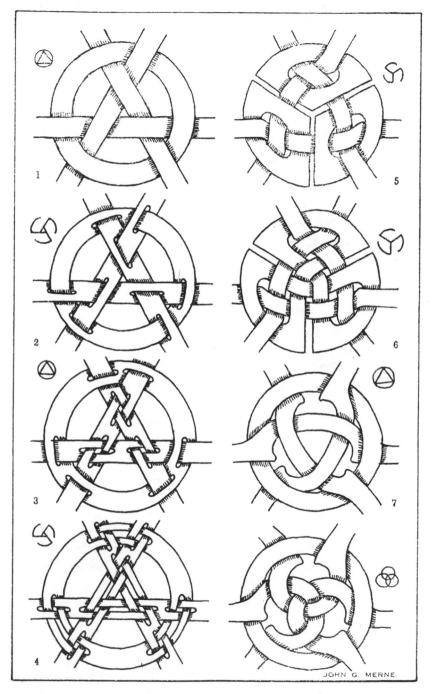

JOHN G. MERNE.

Plate 20

45

21 CROSSOVERS

THIS plate gives examples of new and original crossovers from which many beautiful diapers can be designed by using the strapwork or ribbon to join up the bosses which can be used as the unit of repeat.

1. The ribbons split into two bands and interlaced with four interlacing links. Symbols 5 and 13 combined give the basis on which this pattern is built.

2. The ribbon is here split into two bands and interlaced with a ring. Symbol 13 is used here.

3. Ribbons split in two and interlaced with two loops. Symbol 6 is used in this case.

4. In this case the ribbons are split into three narrow bands, and interlaced with four interlacing links. Symbol 1 is the basis of this unit.

5. Ribbons split in two and interlaced with two loops. Symbol 21 is the basis in this case.

6. In this case the ribbons are split into two narrow bands, and interlaced with a separate ribbon of four loops. Symbol 21 is the basis of this design.

7. The ribbon is here again split into two bands and interlaced with a four loop ribbon. Symbol 22 is the basis.

8. The ribbon is split into seven bands interlaced and the original ribbons joined. Symbol 21 is used in this.

All these designs can be used in the construction of Diapers, as Lattice joints, or as decorative Units or Bosses.

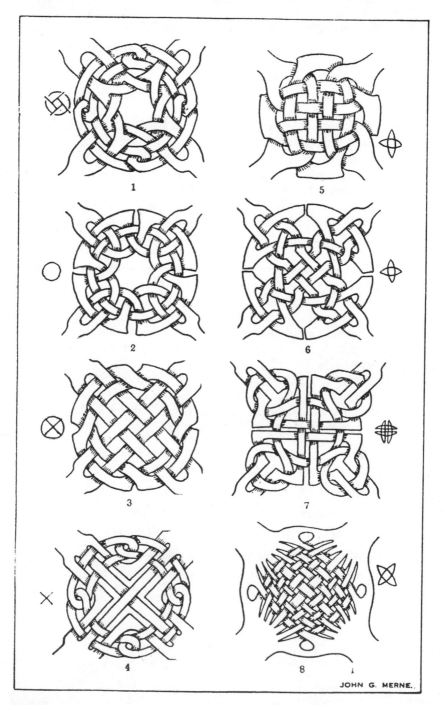

JOHN G. MERNE.

Plate 21

47

22 DESIGNING BY MEANS OF A MIRROR

LET us take for example a border that we wish to return at right angles. The angle of mitre will thus be 45 degrees.

METHOD

Place the edge of a thin mirror on the border at the angle of mitre, holding the mirror face at right angles to the surface of the paper or drawing. The reflection of the border will then be seen in the mirror, at right angles to the border itself. Move the mirror along the border, keeping it at angle of mitre, until a certain position is found where the return looks best. Keeping the mirror in that position, draw a line across the border, using the face of the mirror to act as a straight edge. The line thus drawn is the mitre for that border. It will, of course, be necessary to make slight changes and corrections afterwards, so that the ribbon-work may be complete in every way.

In the case of the examples shown on this plate, the motif from which all the designs were evolved, is given as 1, and a line X—Y is shown drawn across this motif. If a piece of thin mirror be placed on this line so as to give a reflexion of the larger portion, the pattern produced will be the same as 2.

The part of the motif used to produce the other designs is that which is contained within the angle shown in each, and which we will call the unit of repeat. Its reflection in two mirrors at right angles or otherwise produces the resultant pattern.

1. This is the motif used to produce all the patterns on this plate, used in conjunction with a mirror or mirrors.

2. Unit turned over once to produce design.

3. Unit turned over four times to produce design.

4. Unit turned over four times to produce design.

5. Unit turned over six times to produce design.

6. Unit turned over six times to produce design.

7. Unit turned over four times to produce design.

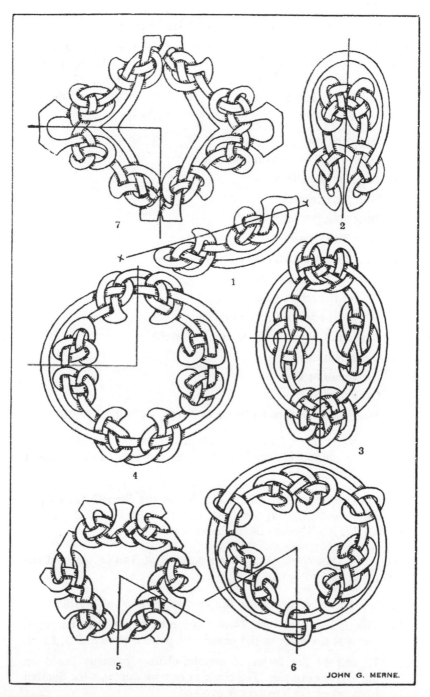

JOHN G. MERNE.

Plate 22

D

49

23 EXAMPLES FROM OLD MANUSCRIPTS

EXAMPLES are here given of different types of motifs found in old manuscripts. These owe their origin to the Swastika Symbol 4, Plate 1, and from them has been developed a number of all-over and counter-change patterns. A careful study of these motifs will make clear all that is set forth in Plates 24 to 28.

1. Step ornament.
2. Four Tau crosses with Swastika.
3. Tessellated pattern.
4: Four Tau crosses.
5. Pattern developed from 2.
6. Four Tau crosses.
7. Simple Fret pattern.
8. Angular Spiral Fret pattern.
9. Diagonal Fret pattern.
10. Marginal ornament, Step and Tau.
11. Portion of Virgin's Chair, Book of Kells.
12. Ornament at A.
13. Ornament at C.
14. Ornament at B.
15. Marginal ornament on frame of Virgin's Chair.

STEP ORNAMENT. A Saw-tooth pattern found on primitive urns. The centre consists of four L-shaped pieces, which can be resolved into two Tau crosses.

TESSELLATED PATTERN. This is similar to the Step Ornament. In the simple and diagonal frets, one can easily trace the Z pattern, Symbol 7, Plate 1, being the underlying principle.

MARGINAL ORNAMENT. This shows a series of Tau crosses and the Saw-tooth pattern ornament.

Ornament 12 consists of four Tau crosses, forming a Swastika.

13. This is the Tau cross. 14 is considered by some to be floral, but it is the same as the tessellated pattern shown in 3, I feel.
16, 17 and 18 are forms of counter-change patterns based on the above examples. The circle at bottom contains the Symbol from which each pattern is evolved.

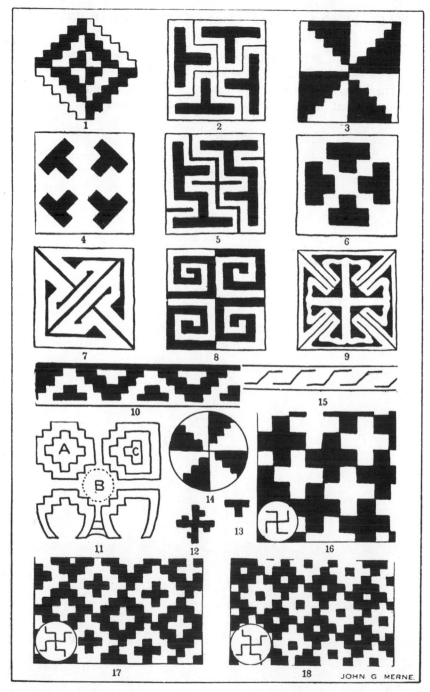

JOHN G MERNE.

Plate 23

51

24 DIAPERS, COUNTER-CHANGE AND ALL-OVER PATTERNS

THE examples given on these plates are based on the Swastika, Tau Cross, Step Ornament, and L and Z symbols.

The basis from which each pattern is derived is shown in the small circle at bottom left-hand corner of each design.

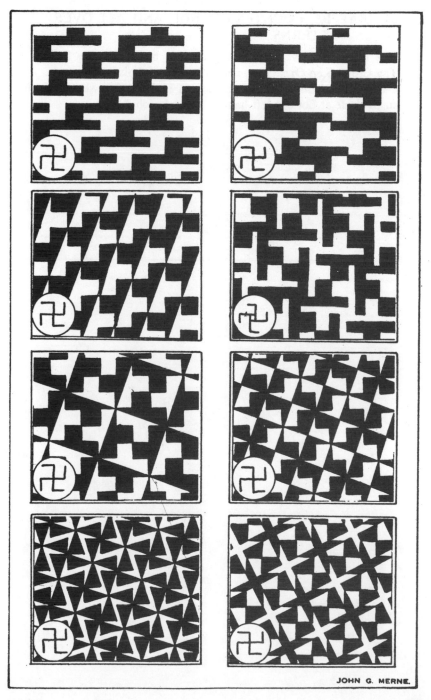

JOHN G. MERNE.

Plate 24

53

25 DIAPERS, COUNTER-CHANGE AND ALL-OVER PATTERNS

THE examples given on this plate are based on the Swastika, Tau Cross, Step Ornament, and L and Z symbols.

The basis from which each pattern is derived is shown in the small circle at bottom left-hand corner of each design.

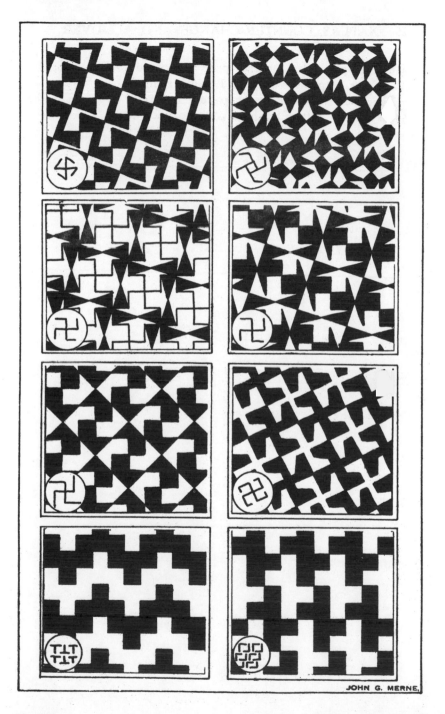

JOHN G. MERNE.

Plate 25

55

26 DIAPERS, COUNTER-CHANGE AND ALL-OVER PATTERNS

THE examples given on this plate are based on the Swastika, Tau Cross, Step Ornament, and L and Z symbols.

The basis from which each pattern is derived is shown in the small circle at bottom left-hand corner of each design.

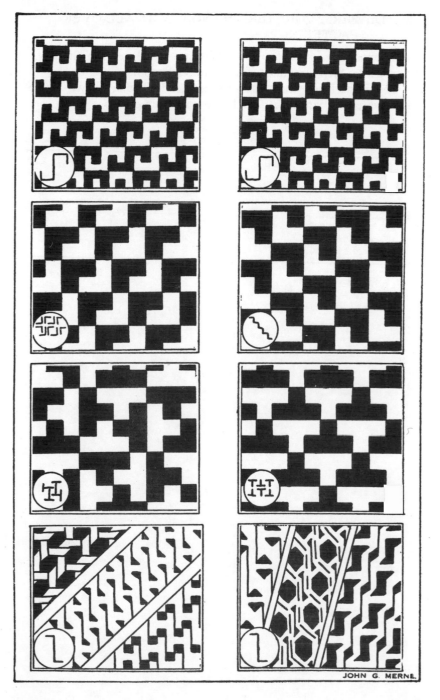

JOHN G. MERNE.

Plate 26

57

27. DIAPERS, COUNTER-CHANGE AND ALL-OVER PATTERNS

THE examples given on this plate are based on the Swastika, Tau Cross, Step Ornament, and L and Z symbols.

The basis from which each pattern is derived is shown in the small circle at bottom left-hand corner of each design.

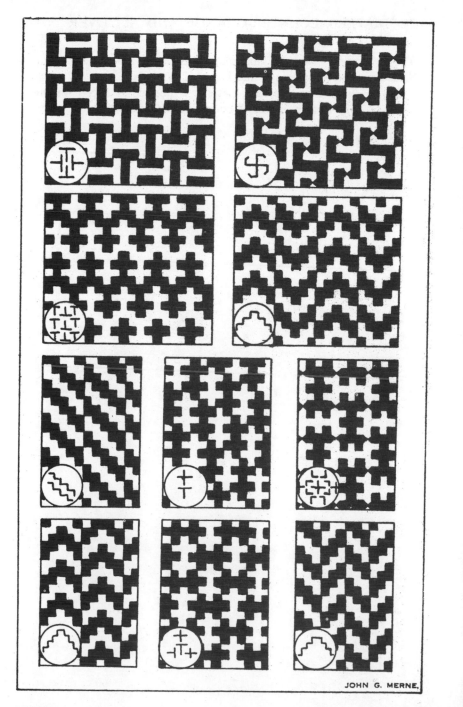

JOHN G. MERNE,

Plate 27

59

28 DIAPERS, COUNTER-CHANGE AND ALL-OVER PATTERNS

THE examples given on this plate are based on the Swastika, Tau Cross, Step Ornament, and L and Z symbols.

The basis from which each pattern is derived is shown in the small circle at bottom left-hand corner of each design.

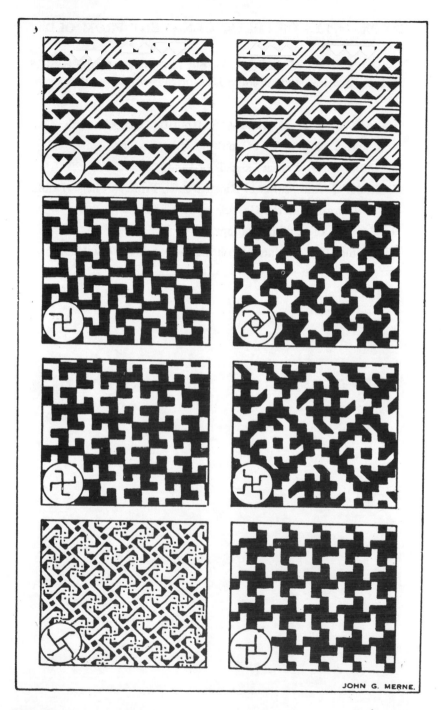

JOHN G. MERNE.

Plate 28

61

29 EXAMPLES OF CELTIC ORNAMENT FROM OLD WORK

THE introduction of this plate of old examples into the book, is done to give the student some idea of the work executed by the old craftsmen.

1 and 2. Interlaced ribbon-work from the Gospels of St. Gaul.

3, 4 and 5. Examples of multiple ribbon-work.

6. Initial letter M from Gospels of Lindisfarne.

7. Letter Q from Psalter of Ricemarchus, Trinity College, Dublin.

8. Bird forms from the Gospels of St. Chad.

9. Example of terminal endings.

10. Zoomorphic ornament from Gospel of Mac Regol, Oxford.

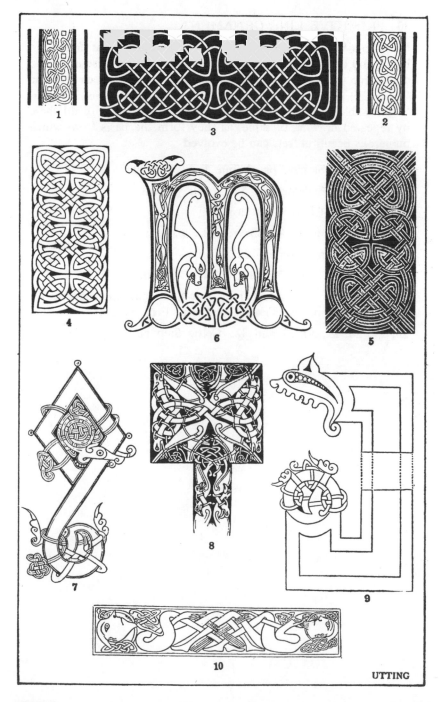

1

2

3

4

6

5

7

8

9

10

UTTING

Plate 29

63

30 PRIMITIVE LINE ORNAMENT

EXAMPLES are here given of primitive line ornament found on burial and other urns. The various arrangements of these lines into decorative units can be easily traced, and it will be seen that the Celtic Fret is a development from these line decorations. It would be advisable for the student to become conversant with all these by repeated drawing of same, as they form the basis from which numerous beautiful frets can be evolved.

1, 2 and 3. Sloping or oblique line ornament.

4, 5 and 6. Indented or Saw-tooth pattern.

7, 8 and 9. Chevron pattern.

10, 11, 12, 13 and 14. Chevron-like pattern.

15. Celtic Step pattern.

16, 17, 18, 19 and 33. Basket-weave pattern.

20, 21, 22, 24, 25. Indented or Saw-tooth pattern, showing the beginning of the Triangular Celtic Fret pattern.

26, 27, 28, 29, 30, 31 and 32. Celtic Step pattern.

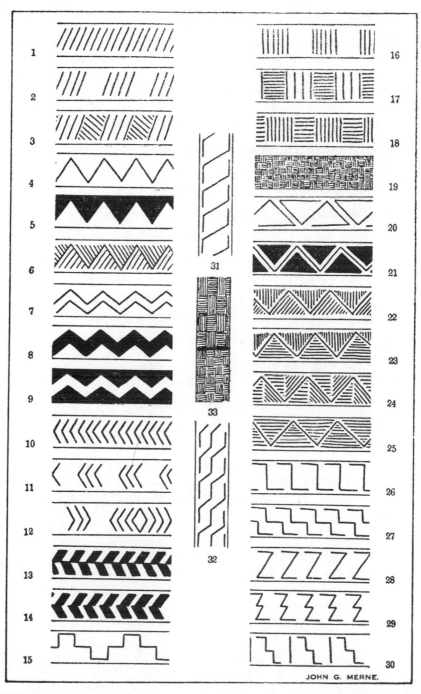

JOHN G. MERNE.

Plate 30

E

65

31 TRIANGULAR FRET PATTERNS

THIS plate shows examples of the Triangular Frets in their different forms and their application to borders. The triangular fret is characteristically Celtic in its form and in the writer's opinion was developed from the line ornament shown on Plate 28. The basis of the fret is the Saw-tooth ornament; on Plate 30 its gradual development step by step from that ornament can be seen.

1. Single strap fret pattern, left hand spiral.

2. Single strap fret pattern, right and left hand spiral.

3. Double strap fret pattern, right and left hand spiral.

4. Single strap fret pattern, right and left hand spiral.

5. Single strap fret pattern, right and left hand spiral.

6. Single strap fret pattern, right and left hand spiral.

7. Single strap fret pattern, with step pattern showing.

8. Single strap fret pattern, right and left hand spiral.

9. Single strap fret pattern, right and left hand spiral.

10, 11 and 12. Single strap fret with step pattern.

13. Simple fret border based on 1.

14. Example of combining various frets.

15. Beginning of fret from saw-tooth ornament.

NOTE

The small black triangles are used to give square endings to the strapwork of the fret. That they may have had some religious significance is probable. See Symbol 25, Sacred Triangles on Plate 1.

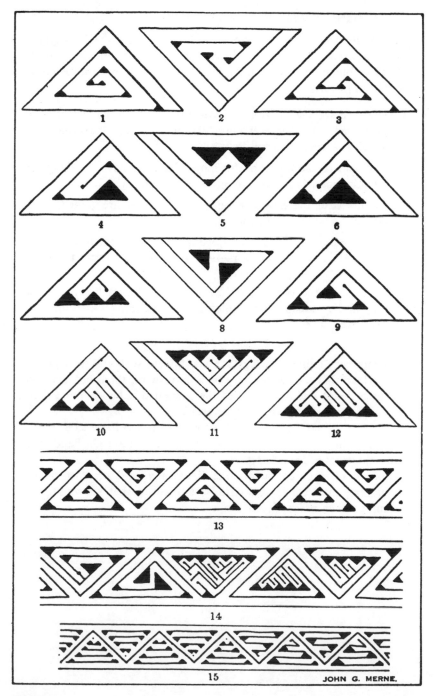

JOHN G. MERNE.

Plate 31

67

32 TRIANGULAR FRET PATTERNS

THIS plate shows the probable method whereby the Triangular Fret Patterns were evolved from the primitive line decoration found on funeral and other urns, which method shows true development and growth.

1. Here we see the saw-tooth decoration which is a form of S or Z incised upon the soft clay, giving a simple line ornament, which is a very common feature.

2. The ends of the lines are thickened. Here we have the dawning introduction of the *triangle* into the decoration.

3. In this case the alternate ends of the lines are joined, thus giving the beginning of the *fret*.

4. By combining stages 2 and 3, we arrive at the fret proper. The next step is to produce horizontal lines outward from the saw-tooth lines, which lines will divide the ribbon.

5 and 6 show the division of the strap or ribbon being carried out, and producing two different fret patterns based on the example above.

A number of line drawings are also given, with the frets partly finished, so that the reader may be able to work them out. By this means a better understanding of the system will be obtained than by giving finished drawings of the frets.

These drawings from 11 to 17 show on the left-hand side of the sheet the simple line ornament, whilst those at the right-hand side show the partly finished fret.

Border 17 is based on oblique lines only, and the method of developing the frets in this case, is similar to that shown in the example which is first given.

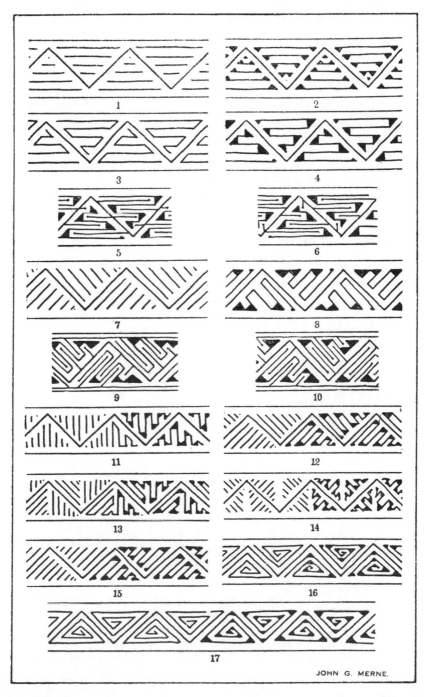

JOHN G. MERNE.

Plate 32

69

33 MODERN BIRD FORMS

SOME examples of the filling of spaces with simple bird and animal-like forms are given on this plate.

1 and 2. Simple snake-like forms.

3. This example shows the unit turned over on itself vertically.

4 and 5 give two different treatments of the same shaped panel in which bird-form is introduced.

6. This circular design is based on the repetition of unit 3, which is arranged in a swastika-like form.

7. In this panel the unit is turned over on itself vertically as in 3.

The method by which this type of ornament is designed is that employed in panel design, in which a foundation line is first arranged and the shapes then built out from the foundation line.

Other methods of feather treatment than those shown will suggest themselves to the earnest student.

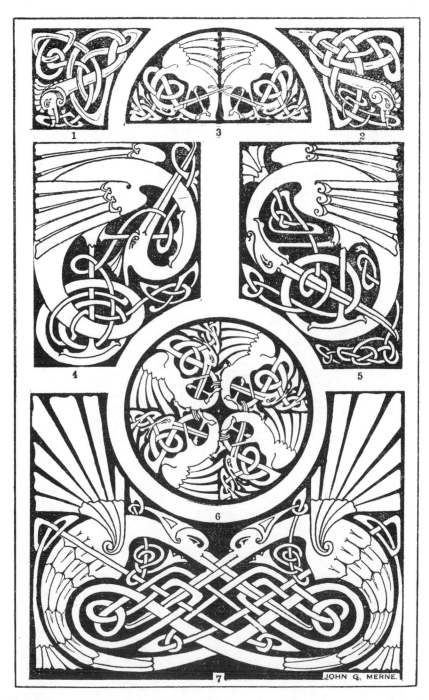

JOHN G. MERNE.

Plate 33

71

34 MODERN TYPES OF FRET PATTERNS

ON this plate will be found an original treatment, which though still retaining the character of old craftsmanship has certainly something to recommend it as a decorative feature, and may be applied in many ways—the introduction of the spiral and C curves in the form of frets for example. Various examples are given as borders, but the idea can also be used in the construction of all-over patterns and for the decoration of irregular spaces and backgrounds.

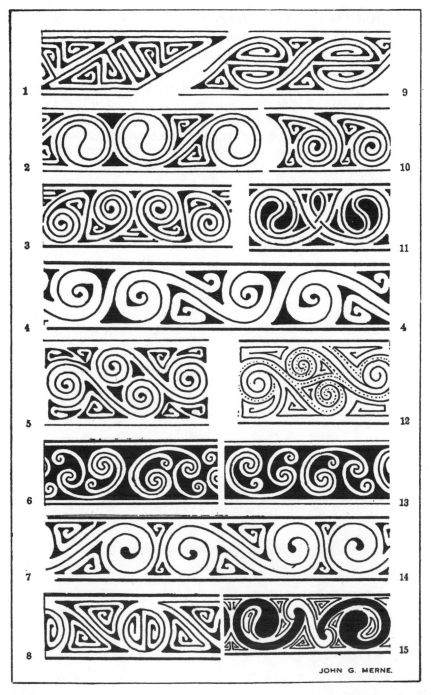

1 9
2 10
3 11
4 4
5 12
6 13
7 14
8 15

JOHN G. MERNE.

Plate 34 73

35 BACKGROUND DECORATION IN LINE

THIS plate shows a method whereby decorative and artistic effects can be got by using simple line-work as a background decoration, keeping the character of the spiral and fret to produce the results. Some examples are given to show how backgrounds can be filled.

The method of doing this can be easily understood, if the surface be first divided into a number of spaces by spirals and triangles, and parallel lines then drawn until the whole surface is covered. A close study of this plate will easily show the simple principle involved and will enable the student to produce similar results.

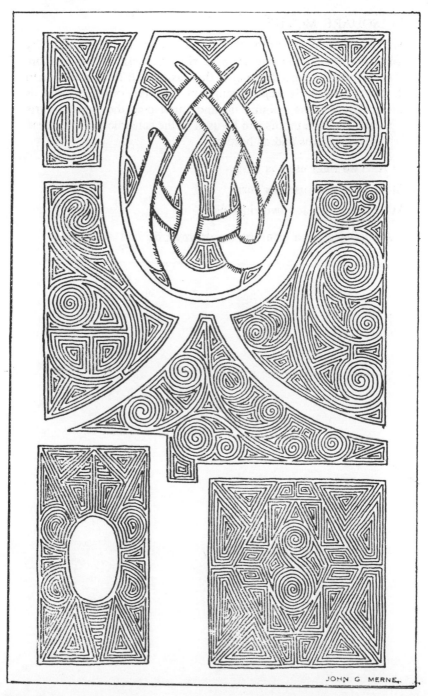

JOHN G MERNE.

Plate 35

THIS plate shows steps in the production of artistic designs by using as a foundation one or more rings or links in combination.

In all cases the top drawing is the basis of all those underneath it. The character is kept throughout, but the original motif is altered by breaking, joining up and interlacing the various parts together. All these motifs can be used in the construction of diapers or all-over patterns and as borders.

At A. Two rings used as basis.

At B. Four links used as basis.

At C. Two links and two rings used.

All drawings read from the top downwards.

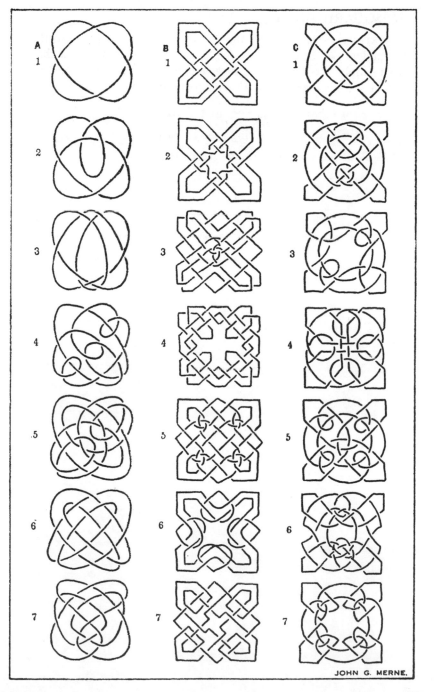

JOHN G. MERNE.

Plate 36

77

37 SQUARE MOTIFS

A FURTHER series of square motifs are given on this plate, so that the student will be able to see for himself the development of these from simple to complex, and that he can use them in the construction of various diapers and all-over patterns and as borders.

At D. Four loops and one ring used as basis.

At E. Four loops and one ring used as basis.

At F. Four links and two rings used as basis.

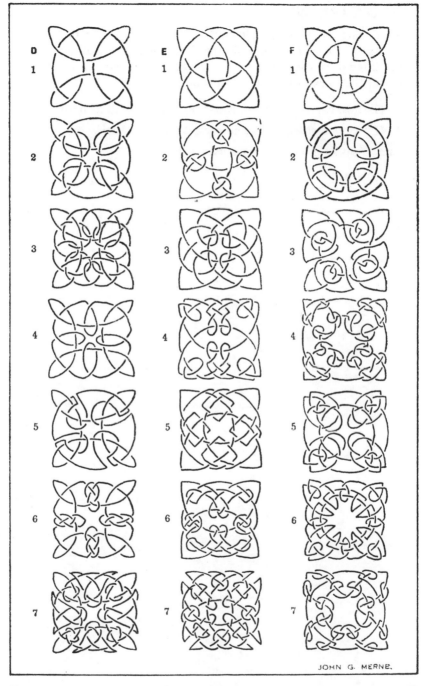

JOHN G. MERNE.

Plate 37

38 SQUARE MOTIFS

THIS plate contains another and final series of square motifs for the use of the student in designing. They will be found useful for the filling of panels of various shapes, as they can be easily adapted to suit the work in hand by re-drawing.

At G. Two curved links and two straight links used as basis.

At H. A cross-shaped link and one ring used as basis.

At J. Two links and five rings used as basis.

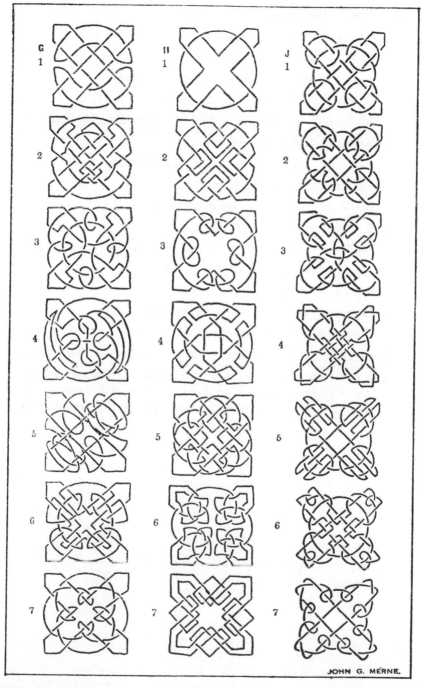

JOHN G. MÉRNE.

Plate 38
F

81

39 LOOP BORDERS AND DIAPERS

1. Border of loops with supporting line.
2. Border of two loops upright, locked.
3. Border of single upright loops with rings, locked.
4. Border of single upright loops with figure 8 links.
5. Border of single loops with double wave undulating line.
6. Border of "up and down" loops.
7. Border of "up and down" loops locked. Granny knot.
8. Border of three upright loops linked.
9. Border of "two up and one down" loop.
10. Border of three loops joined.
11. Border of "one up and one down" loops with figure 8 link.
12. Border of two upright loops with double wave line.
13. Border of "two up and two down" loops.
14. Border of "up and down" loop with double-wave line.
15. Border of "three up and one down" loops.
16, 17, 18 and 19 are examples of diapers formed from loops.
17, 18 and 19 are of Granny Knot construction. All these sketches are given in simple line, so that the student will easily understand the method of construction of both borders and diapers.

1
2
3
4
5
6
7
8
9
10
11
12
13
14
15
16
17
18
19

JOHN G. MERNE.

Plate 39

83

40 KNOT-WORK DIAPERS

THE introduction of continuous diapers into Celtic work is an innovation that probably will cause some comment, but it is hoped that the results shown will justify their adoption into that art.

Examples are here shown on this plate of diapers constructed by connecting a number of knot units to form all-over patterns. An infinite variety of diapers can be designed in this manner by first drawing the definite knot as in panel designing, leaving the four ends of the ribbon-work free to join up to the other knots.

Arrange the knots in horizontal lines as shown on this plate spacing them so as to form a net and then joining the loose ends of the knots to one another in graceful lines. The panel space can be filled in with ornament, if one so desires.

The drawings on this plate are given in simple line, so that the student will be easily able to follow the system of constructing diapers of his own.

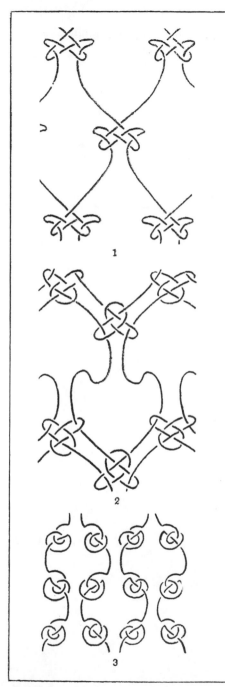

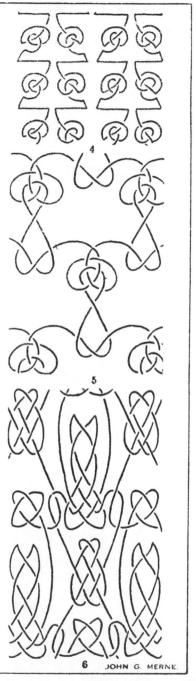

1

2

3

4

5

6 JOHN G. MERNE.

41 SPACE FILLING

THIS plate gives several examples of irregular space-filling with ribbon-work as well as background treatment.

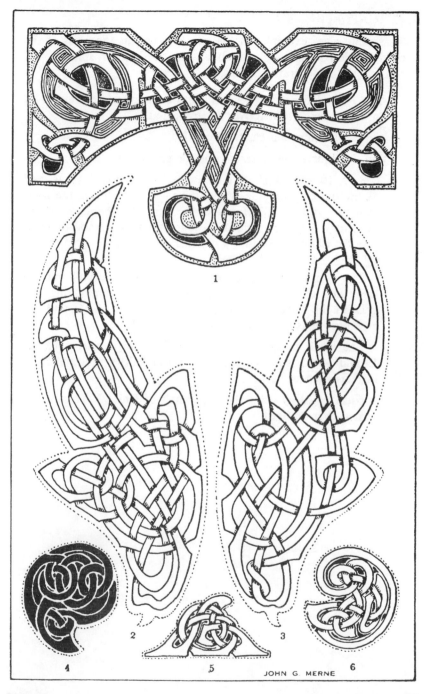

JOHN G. MERNE

Plate 41

87

42 UNITS

THIS plate gives examples of the use of a unit as the basis of the different designs shown as well as the method of splitting the strap-work for decorative effects.

1, 2, 3, 4 and 5 are all derived from different arrangements of a unit, 1 being turned over and repeated.

2 and 3. Borders constructed from 1.

4 and 5. Square tile patterns constructed from 1.

6, 7, 8, 9, 10 and 11 show the interlacing of two links as well as the different modifications arrived at by splitting the links into two ribbons and interlacing them, the character of the first motif 6 being retained throughout. This method of splitting the ribbon-work into a number of parts gives great scope for inventiveness in design.

The two square tile designs, 17 and 18, are built on the same unit of repeat shown as 15. The top point of this unit goes to the outside of 17, and to the inside of 16, and the crossover ends of units are closed or joined.

The small panel design 12 is utilised to construct panels 13 and 14. 13 is got by using the lower half of unit and turning this over on itself.

14 is constructed by using the upper half of Unit 12. This is also turned over on itself.

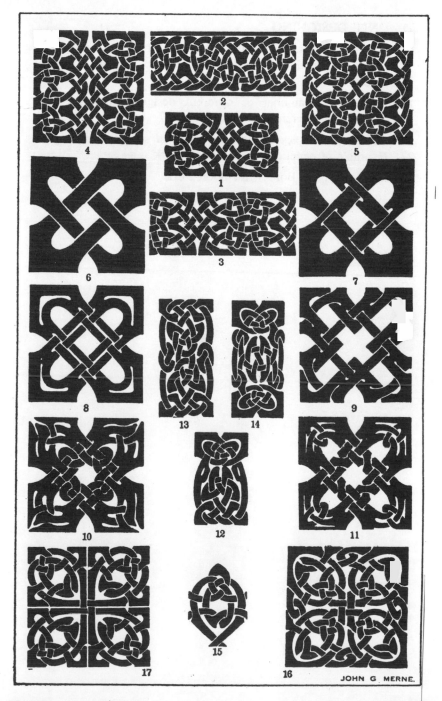

Plate 42

89

43 UNIT DESIGNING

1 to 16 on this plate show the Simple Knot and its application to the construction of Borders and Panels. 1 being the unit of repeat.

17 to 21 show a number of different designs which are produced from different arrangements of 17.

22 to 26 give examples of different forms of simple knot diapers.

27. Example of panel design in ribbon-work.

28. Modern type of Border in ribbon-work.

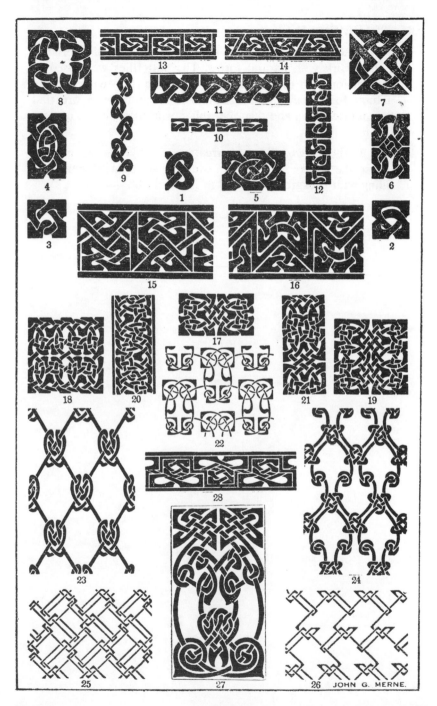

JOHN G. MERNE.

Plate 43

91

44 SPACE FILLING

1. This panel shows an example of the combination of interlaced ribbon-work with natural forms. The butterflies were used in conjunction with the ribbon which acts as a framework for any natural forms being introduced. The natural forms are first drawn in position and then the ribbon-work designed to enclose them.

2 and 3 show two different treatments of ends of panels, whilst the centre 4 gives an example of light ribbon-work filling with background treated in line and dot.

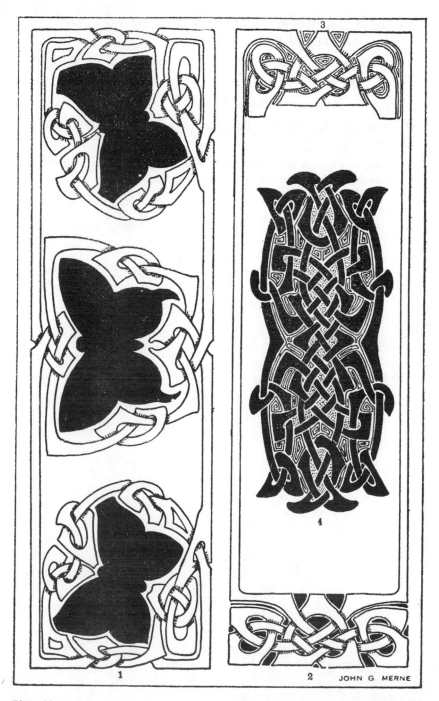

JOHN G. MERNE

Plate 44

93

45 APPLICATION OF RIBBON-WORK TO LEATHERCRAFT

THE sketches on this plate are typical of the type of ribbon-work that is suitable for Leathercraft.

1 is a small leather Pocket Wallet.

2. Here the ends of the interlaced ribbon are treated as birds' heads.

3. This is a design for a bead bag which was finished in brilliant colours, which gave it an enamel-like effect.

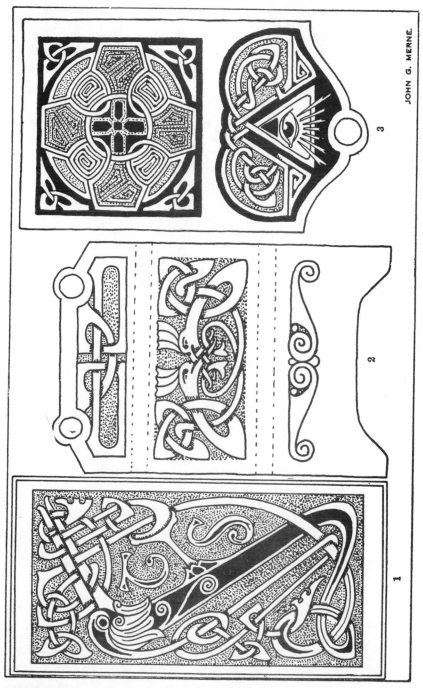

Plate 45

95

46 DIAPERS

A NUMBER of examples are given on this plate of various types of diapers, the construction of which will be easily understood by the student who has carefully followed the writer's method as explained on Plates 14, 39 and 40.

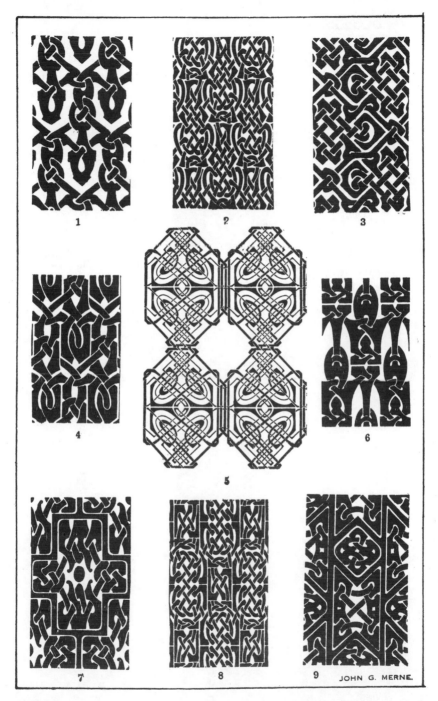

1

2

3

4

5

6

7

8

9

JOHN G. MERNE.

Plate 46

97

47 DIAPERS

OTHER examples of diapers of useful decorative value are given on this plate, so that the student will be able to see the enormous range of different designs that can be got from a knowledge of the knots, and the arrangement of these into various decorative patterns.

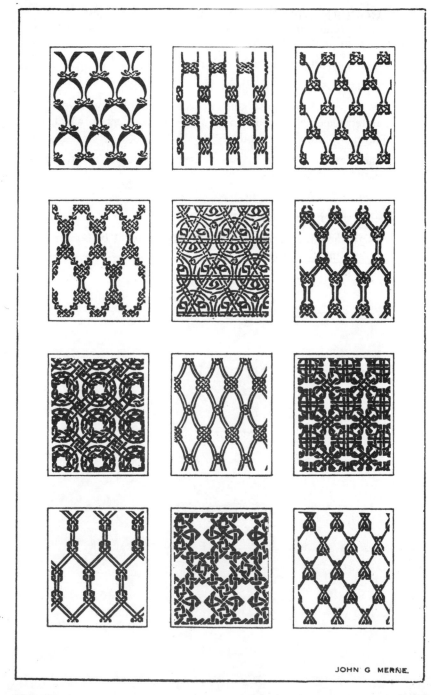

JOHN G MERNE.

Plate 47

99

48 MODERN APPLICATION OF CELTIC WORK

ON this plate are given a number of examples of the use of Celtic ornament in modern design.

1. Playing-card back in Ribbon-work.

2. Playing-card back with Bird forms.

3. Design based on Rose and Peacock suitable for leaded or painted glass. Note the treatment of tail feathers in which the Trumpet pattern is embodied.

4. Panel design suitable for wood-carving or leather work. Roots treated as ribbon-work.

5. Panel design for leadlight.

6. Celtic stencil treatment.

7. Design for book jacket. Ribbon-work treatment of border and fret treatment of panels.

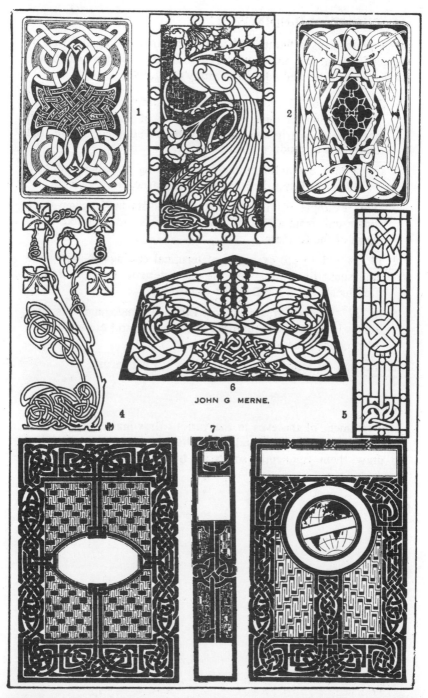

1

2

3

6

JOHN G MERNE.

4

5

7

Plate 48

101

49 TERMINAL ENDINGS

THIS plate gives a number of useful terminal endings as well as suggestions in the treatment of Zoomorphic forms which the student would be well advised to study carefully.

1, 2, 3, 4, 5, 6, 10 and 11 give some examples of Animal and Bird terminal endings, from the Book of Lindisfarne, which show very clearly the simple methods adopted by the old craftsmen to produce artistic results.

7 and 8 give examples of the type of wing treatment adopted in old work. From the Book of Lindisfarne.

9. This example from the Book of Lindisfarne is given as a single unit from a bird border, and shows the scale-like treatment of the feathers.

12, 13, 14 and 15 are examples of terminal endings showing bird and snake-like forms with the characteristic Trumpet Pattern treatment. From the Book of Lindisfarne.

16 to 22. Modern treatment of Bird, Animal, and Fish-like forms in which the Trumpet Pattern and Spiral are introduced to produce decorative results.

23. Method of treating the Tail or Fin in Fish forms.

NOTE

The treatment of the eyes in the various drawings shown on this plate are well worthy of study, and the student would be advised to draw them frequently so as to become familiar with each particular type.

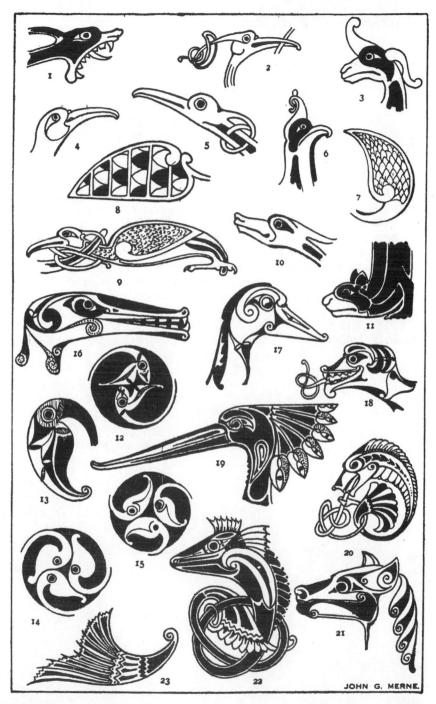

JOHN G. MERNE.

Plate 49

103

IRISH SYMBOLS
by Neil L. Thomas

The riddle of the inscriptions at Newgrange, Knowth and other equally ancient Irish sites in the Boyne valley has been partly deciphered at last.

The inscribed passage mound stones tell of prehistoric man's concept of the world; the flat earth with a hemispherical bowl overhead, the sun and the moon circling around.

The legends and myths of Ireland can be directly related to the stone engravings; certain numbers such as nine, eleven, seventeen, twenty-seven and thirty-three are common to both. These numbers have important symbolic meanings as well as their numerical values.

The oldest calendar in the history of mankind is portrayed – sixteen months of 22 or 23 days, four weeks of five days each month, eight annual solar and seasonal events. It has been known for some time that the passages into the Newgrange and Knowth mounds are aligned with sunrise and sunset on the solstitial and equinoctial days each year. They are the cornerstones of the sixteen month calendar and the eight annual festival days.

The Irish evidence from 3500 BC to 3200 BC precedes British calendar building sites at Mount Pleasant 2600 BC and Stonehenge 2000 BC.